MARCH
MONTHLY
ACTIVITIES

Written by Janet Hale

Illustrated by Blanqui Apodaca, Paula Spence, and Keith Vasconelles

Teacher Created Materials, Inc.
P. O. Box 1214
Huntington Beach, CA 92647
© *Teacher Created Materials, Inc. 1989*
Made in U. S. A.
ISBN 1-55734-157-5

Table of Contents

Table of Contents

(cont.)

Introduction

March Monthly Activities provides 80 dynamic pages of ready-to-use resources, ideas and activities that students love! All are centered around the themes, special dates and holidays of the month.

A complete "month-in-a-book," it includes:

- *A Calendar of Events* - ready to teach from and filled with fascinating information about monthly events, PLUS lots of fun ways you can apply these useful facts in your classroom.

- *A Whole Language Integrated Teaching Unit* - theme-based planning strategies, projects, lessons, activities, and more that provide a practical, yet imaginative approach to a favorite seasonal topic.

- *People, Places and Events* - an exciting series of activities that relate to the daily events in the Calendar of Events, and provide an innovative way for students to reinforce skills.

- *Management Pages* - a supply of reproducible pages that take you through the month, providing a wealth of valuable organizational aids that are right at your fingertips.

- *A Bulletin Board* - featuring a "hands-on" approach to learning; complete with full-size patterns, step-by-step directions, and tips for additional ways you can use the board.

Ideas and activities are also included for:

- *math*
- *geography*
- *literature ideas*
- *art projects*
- *social studies*
- *cooking*
- *reading*
- *stationery*
- *reports*
- *science*
- *creative writing*
- *seasonal words*

March Monthly Activities is the most complete seasonal book you'll ever find, and its convenient, reproducible pages will turn each month into a special teaching-and-learning-experience!

Using The Pages

March Monthly Activities brings you a wealth of easy-to-use, fun-filled activities and ideas that will help you make the most of March's special themes and events. Although most of the activities are designed to be used within this month, if the holidays and traditions vary in your location, you may easily adapt the pages to fit your needs. Here are some tips for getting the most from your pages:

CALENDAR OF EVENTS

Each day makes note of a different holiday, tells about a famous person or presents a historical event. A question relating to each topic is provided (answers are on page 76). Teachers can use these facts in any number of ways including:

- *Post a copy of the calendar on a special bulletin board. Each day assign a different student to find the answer to that day's question. Set aside some time during the day to discuss the question with the whole class.*

- *Write the daily fact on the chalkboard. Have students keep a handwriting journal and copy the fact first thing each morning. They must use their best handwriting, of course!*

- *Use a daily event, holiday or famous person as a springboard for a Whole Language theme. Brainstorm with the class to find out what they already know about the topic. Explore the topic through literature, the arts, language and music.*

- *Older students can write a report on any of the daily topics. Younger students can be directed to draw a picture of the historical event or figure.*

- *Have students make up their own questions to go along with the day's event!*

- *Assign each student a different day of the calendar. Have them present a short oral report to the class on that day's topic.*

- *Use the daily events for math reinforcement. Ask how many: Days, weeks, months and years since the event occurred (for a real brain teaser, have students compute hours, minutes and seconds).*

- *Use in conjunction with the People, Places and Events section (pages 32 - 46).*

BLANK CALENDAR

Copy a calendar for each student. Have students use them to:

- *Write in daily assignments; check off each one as completed.*

- *Set daily goals—behavioral or academic.*

- *Copy homework assignments.*

- *Fill in with special dates, holidays, classroom or school events.*

- *Keep track of classroom chores.*

- *Use as a daily journal of feelings.*

- *Make ongoing lists of words to learn to spell.*

- *Answer the Question of the Day (see Calendar of Events).*

- *Record daily awards (stamps, stickers, etc.) for behavior or academic achievement.*

- *At the end of the day, evaluate their attitude, behavior, class work, etc. and give them a grade and explanation for the grade.*

- *Log reading time and number of pages read for "free reading" time.*

- *If there are learning centers in the classroom, let students keep track of work they have completed at each one or copy a schedule of times and days they may use the centers.*

- *Each day, write at least one new thing they learned.*

MANAGEMENT PAGES

Nifty ideas for extending the use of these pages.

- **Contracts** - *Help students set long or short term goals such as keeping a clean desk, reading extra books or improving behavior.*

- **Awards** - *Show students you appreciate them by giving awards for good attitude, helping, being considerate or for scholastic achievement. Students can give them to each other, their teacher or the principal!*

- **Invitations** - *Invite parents, grandparents, friends or another class to a classroom, school or sports event.*

- **Field Trip** - *Use for class trips or have students use in planning their own "field trip" to another country or planet.*

- **Supplies** - *Tell parents when you need art, craft, classroom, physical education or any other kind of supplies.*

- **Record Form** - *Place names in alphabetical order to keep track of classroom chores, completed assignments, contracts or permission slips.*

- **Stationery** - *Use as a creative writing pattern, for correspondence with parents, or for homework assignments.*

- **News** - *Fill in with upcoming weekly events and send home on Monday or let students fill in each day and take home on Friday. Younger students may draw a picture of something special they did or learned.*

- **Clip Art** - *Decorate worksheets, make your own stationery or answer pages. Enlarge and use for bulletin boards.*

Hot Tips!

Be sure to look for the hot tips at the beginning of each section—they provide quick, easy and fun ways of extending the activities!

March Highlights

- **Calendar of Events**
- **Spelling Activities**
- **Story Starters**
- **Gameboard**
- **Poetry**
- **Art Project**
- **And More!**

Hot Tips!

🍀 Here's a fun idea for a monthly calendar: give each student a blank square of paper and allow them to make an appropriate "background scene" for one day of the month. Then, use a black marking pen to write the number of each day in the corner of each square. Place in order on a blank calendar board/chart.

🍀 To "save" your blackline masters, take a photocopy of page desired rather than tearing out the page!

March

March is the third month of the year. It's name is taken from the Roman god of war, Mars. This month is most famous for "marching" in spring and saying good-bye to winter.

Flower: Violet Birthstone: Aquamarine

Peace Corps Day

1

What is a volunteer?

Save Your Vision Day

5

20/20 stands for what?

"Remember the Alamo"

6

Where is this famous fort?

Luther Burbank's birthday.

7

What does a horticulturist do?

President Chat Day (on the radio)

12

Who is your President/Prime Minister?

Uranus discovered in 1781.

13

Does Uranus have any moons?

Albert Einstein born in 1879.

14

What does $E = MC^2$ mean?

Alexei Leonov, first to walk in space, 1965.

18

What country was he from?

Swallow Day in San Juan Capistrano, CA.

19

How long have the birds been returning to San Juan Capistrano?

First Day of Spring

20

What are the other 3 seasons?

Memory Day

21

Can you remember your favorite memory?

Robert Frost born in 1874.

26

What does a poet write?

Egg Race Day

27

How many eggs equal 1 dozen?

Washing Machine invented 1797.

28

What was used before this invention?

88th day of the year.

29

How many days left?

Dr. Seuss born, 1904 **2** *What is Dr. Seuss's real name?*		**Alexander Graham Bell's Birthday** **3** *What did he invent?*	**March has 31 days** **4** *What other months have 31 days?*
International Women's Day **8** *Who is your favorite woman?*	**March comes in like a lion...** **9** *... and goes out like a _____?*	**Harriett Tubman Day** **10** *What was the Underground Railroad?*	**Johnny Appleseed Day** **11** *Eat an apple a day and.....?*
First blood bank established, 1937. **15** *What is your blood type?*	**Vitamin C discovered, 1932.** **16** *What foods have Vitamin C in them?*	**St. Patrick's Day** **17** *What is the Blarney Stone?*	
Marcel Marceau born in 1923. **22** *What does pantomime mean?*	**"Give me liberty or give me death"** **23** *Who said this famous quote?*	**Harry Houdini born, 1874.** **24** *What is another name for prestidigitator?*	**Mt. Rushmore Day** **25** *What 4 presidents are represented on Mt. Rushmore?*
	Happy Doctor's Day **30** *What kind of a doctor would you like to be?*	**Newfoundland, Canada became a province, 1949.** **31** *Is it the ninth or tenth province?*	**Other holidays:** ■ *Music In Schools Month* ■ *Purim (Jewish Holiday)* ■ *Youth Art Month* ■ *National Wildlife Week* ■ *Easter (some calendar years)*

MARCH

SUNDAY	MONDAY	TUESDAY	WEDNESDAY	THURSDAY	FRIDAY	SATURDAY

March Words and Activities

March Word Bank

March	plant	shamrock
music	water	leprechaun
melody	soil	pot
singer	air	gold
artist	bloom	rainbow
writer	succulent	wish
sculptor	landscape	magic
museum	garden	lucky

Spelling Activities

Use the Word Bank above. Have students complete the individual and/or team assignments.

Individual

- *Have students classify the words into 3 categories:*

 St. Patrick's Day
 Plants
 Art and Song

- *Put the words in alphabetical order.*

- *Have students write -R controlled words, using a crayon marker for the vowel-plus-r in each word:*

 sing**er** a**ir** sculpt**or**

- *Make up a song using some of the spelling words.*

Team

- *Give students pre-cut shamrock shapes (clip art p.63). Have them make up sentences using the spelling words, one word per shamrock.*

- *Allow 2 teams 10 minutes to come up with a simple definition for each word. Then, play "Definition Bee." Have each side give one of their definitions; the other team must guess and then spell the word.*

- *Play charades with the spelling words. The guessing team must spell out their answer!*

Story Starters

☐ **Color Wheel**
Make a wheel using a round cardboard disk and spinner; divide the disk into eight sections. Write the name of a different color in each section. For creative writing exercise, have a student spin the spinner — the color it lands on will be the focus for your writing activity.

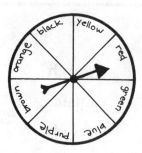

Example:
In the kingdom of red, there was a red castle with rubies and diamonds in the walls. . .

Options for spinning wheel: Use combinations of colors; spelling words; social studies or science words; "make believe" words; students' names.

☐ **Story Puzzles**
Provide a sheet of sturdy paper for each student. Direct them to write a simple story and illustrate it on *one side* of paper. Then have them cut the paper into 6-8 pieces and mix them up. Allow students to exchange puzzles, put together and read. Give each student an envelope to store their story puzzle in. For extra reading, place the envelopes at a reading center.

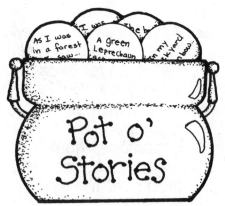

☐ **Pot O' Stories**
Make a hands-on bulletin board using the pot pattern (p. 65). Duplicate the pot onto black construction paper and cut out; use yellow construction paper to make circles for "gold." Write a story starter on each one. Some suggestions are:
- As I was in a forest I saw. . .
- A green leprechaun asked me to go. . .
- In my backyard I saw a rainbow. . .
- The bag of gold was in my hand when. . .

Allow students to come up and get a "piece of gold" and start their story writing activity.

Name _____ Date _____

March Open Worksheet

Directions: _____

DINOSAUR FUN

Name _____ Date _____

Green Things

Find 12 things that are green. Words may be across, down, diagonal, or backwards. Use the WORD BANK.

```
              D A V E Y D
            A N D M D G D U D I
            S R E C I O P O D Y C I
            R T A F R C A L G R T C
            W B I F Y S R L X E F K
            N F V L O D S A F L I Y
            U B Y K O C L R N E R P
            T A G O J C E Z E C V O
            S D H G B C D F P F
      A F       O M R I P O H A O O A G R E
    A T D M D G D U X S A T E R D M D G D U A R T
    I R M I N T P O D Y C A R R M B N T P O L Y C A A
    H T A F R C A L G E T R I T A F R C A L E E S B N
    R B I V E S E L X L F U R B I V Y S R L T L U R N
    U F D L A R E M E S I F T F L E O D S A T S T A E
    E B R E F C L R I R R A P B R K F C L R U R C T R
    D S H A M R O C K L V A N A G O J Y E Z C A A S A
    Y S D F G B Y D F P F A R S D H G B Y D E P C A
    S A M I P I H A W   M A T   I P I H A W O R K
    V F U H R W Q                 M E S S
```

WORD BANK

Cross off each word as you find it in the puzzle.

broccoli	celery	ivy
cactus	emerald	frog
leaf	lettuce	lime
mint	parsley	shamrock

Cocoon To Butterfly Gameboard

Directions: Use this gameboard for any subject area. Label each box with math, spelling or science facts (see pages 78-80). Students may move one space at a time, or you can determine the number of moves with a die.

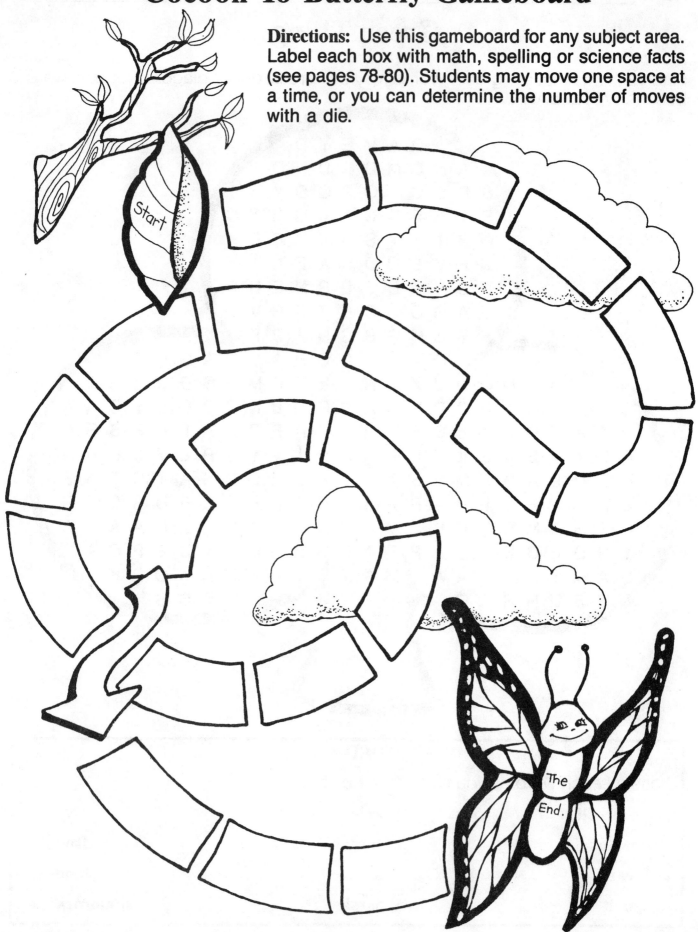

16

Game Page

Tap It Out! — An Indoor game

Here is a great game to play when you want your room to be nice and quiet, and yet allow your students to have an enjoyable time.

Have the class (except "the tapper") go towards one side of the room and face away from the tapper. The tapper taps an item in the room with a pencil. Without turning around, the other students take turns guessing what is being tapped. The first player to guess correctly becomes the tapper.

Silent Movie Race — An Outdoor Game

March is Art Appreciation Month. One of the earliest forms of movie "art" was the "silent movie." A famous star from that time was Charlie Chaplin. After showing a Charlie Chaplin movie or video (remind students to pay attention to his walk!) take your students outside to play this fun game.

Equipment: A balloon; cane; pillow or cushion

Divide the class into two teams. In turn, each player has to put the balloon between their legs, twirl the cane, and balance the pillow all at the same time, to create a "Charlie Chaplin" walk.

Each team member walks to a designated point and back. The first team to finish their "Charlie Chaplin" relay is the winner. Why not award bags of popcorn to all for your next movietime treat!

Poetry Page

■ **Rhythm Band**—An alternative to simply reading rhyming poetry to your students: As a pre-writing experience, hand out (or have students actually make) noise makers, drums, and tamborines. Let students listen to a poem (written on large paper) once or twice, listening for the beat and rhyming words. Allow students to create a "rhythm band" and play the instruments on the beat and rhyming words.

Example-

Mary had a little lamb
△ △ △ △ △△ △
Its fleece was white as snow
△ △ △ △ △
And everywhere that Mary went
△ △△ △ △ △ △
Her lamb was sure to go.
△ △ △ △ △△

■ **"I Have. . ."** This poetry activity is designed for students to increase self-awareness. It can be used to help students develop understanding about their:

— physical characteristics
 (see poem at right)
— personal likes
 (I like. . .)
— personal dislikes
 (I don't like. . .)
— favorites
 (I love to. . .)

> **BILLY JOE**
>
> I have <u>brown eyes</u>, like my <u>sister</u>.
> I have <u>blond hair</u>, like my <u>dad</u>.
> I have <u>long legs</u>, like my
> <u>bunkbed</u>.
> I wear <u>glasses</u>, like my <u>friend</u>
> <u>Mike</u>.
> I have <u>braces</u>, but my <u>sister</u>
> <u>Nicole</u> doesn't.

Art Project

Materials:

Black marking pens, Butcher paper, crayons, the sun!

Directions:

1. Have students divide up into teams of two people per team.

2. Provide each team with two large sheets of butcher paper and a marking pen. Go outside into the sun.

3. Have each team outline each other's shadow onto the paper with marking pen.

4. Then, have team members exchange their shadow with another member of the team. Direct them to turn it in a different direction from the original shadow shape, and create a new picture.

5. Display "Shadow Art" in classroom, library, or entryway to school building.

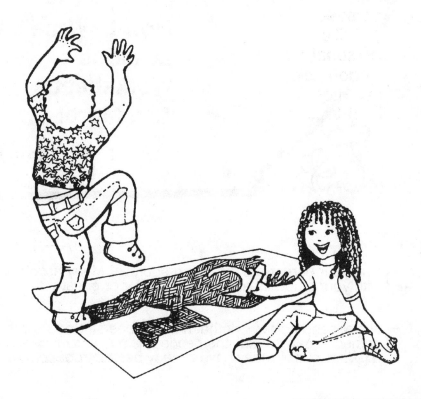

March Whole Language Unit:

PLANTS

- How to Write a Unit
- Lessons
- Worksheets
- And More!

How To Plan

Spring is starting to "march" in! What a perfect opportunity to share facts about fascinating plants from around the world, as well as to learn the cycle of plants. This unit has been designed to encourage taking individual responsibility for our environment; appreciating its beauty; and providing an understanding of plant care. Begin your unit by following these step-by-step guidelines.

 Set the mood by displaying a plant bulletin board (patterns pp. 71-75).

 Assemble your resources—Don't forget guest speakers, possible field trips, books, films, and real objects.

 Plan general lessons integrating math, reading, language arts, science, art, and music.

 Outline your goals and objectives.

 Make evaluation tools that are appropriate for the lesson.

 After the first week of lessons, evaluate and then plan for the next week.

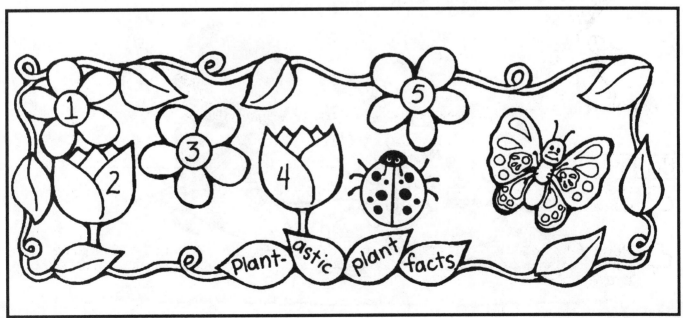

Projects and Lessons

The following pages describe specific lessons and ideas that can be used to integrate the curriculum through the study of plants.

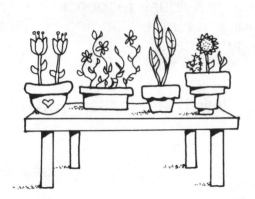

■ **Set up a Plant Pot-pourri display**—*As you open your plant unit, have students observe the different types of plants on display. Divide students into groups of 4-5 and have them write down what they observe (roots, leaves, flowers, thorns, size, etc.). Use as a starting point for your first lesson.*

■ **Let parents know** *your monthly plans through a March news bulletin. Include such information as upcoming activities, special events, and class projects. Use the bulletin to enlist volunteers or request any necessary supplies you'll be needing throughout this unit.*

Science

■ **Living/Non-Living Things**—*Before students can truly understand the concept of a "plant," they need to comprehend the difference between "living" and "non-living" things. Use the chart (p. 49) to outline the differences, then have students divide into teams and take their living/non-living things books (p. 50) outside and classify appropriate items into each book. Add finished books to the Plant Pot-pourri display for students to read during their free time.*

Projects and Lessons

Geography/Science/Language Arts

■ **Plant Regions.** *To expand student's knowledge of the world, allow them to explore the different continents through the types of plants found in different plant regions. Listed below are the* ● *five major regions,* ▲ *continents,* ❀ *plants in those regions, and possible activities.*

TUNDRA AND HIGH MOUNTAINS	FOREST	GRASSLANDS
● Very cold, land frozen most of year. Tundra has no trees, while high mountains have small shrubs. Very little rain. ▲ North/South Pole, Northern Europe, Asia, America Highest mountain tops: Alps, Himalayas, Andes, Rockies ❀ Alpine, Fir, Forget-Me-Not, Lichen, Sheeplaurel, Bristlecone Pine	● Covers about 1/3 of the world's land. **Categories of forests:** ▲ Needleleaf, Northern Europe, Asia, America Cold winter/Cool summer ❀ Cedar, Fir, Hemlock, Pine, Redwood, Spruce ▲ Tropical Rain Central America and Central Africa, Southeast Asia, Pacific Islands Warm, wet weather ❀ Orchids, Vines, Ferns, Mahogany, Teak, Mushrooms, Lichens	● Open grassy areas . Farmers grow crops in these areas. Wild animals roam here. ▲ Great Plains of USA, Canada, veldt of South Africa, plains of Soviet Union. 3 types of grasslands: 1. Steppes—short grasses 2. Prairies—tall grasses, rich soil, so lots of agricultural plants 3. Savannas—tall grasses, Acacia, Palm, Baobab
DESERT	**AQUATIC**	**ACTIVITIES**
● Covers 1/5 of the world's land. Very hot, not much rainfall. Rocky or sandy soil. ▲ Northern Africa, Central Asia, Western South America and Australia, Southwest North America. ❀ Cactus, Creosote Bush, Joshua Tree, Palm Tree, Sagebrush, Yucca, Wild Flowers, Succulents	● Regions of fresh or saltwater. Receive sunlight through water. Some live completely under water, others partly under and on top. ▲ Freshwater—lakes ❀ Diatoms, Algae, Pondweeds, water lillies, cattails. ▲ Saltwater—Oceans ❀ Red Algae, Kelp, Eelgrass, Salt–marsh and salt–meadow Cordgrass	Using a world map, label region areas. Divide class into team reporters and research various plants. Draw a mural for each region using encyclopedia for picture references. Do a "Plant Play" having students describe their features and region. Take a field trip to local greenhouse or arboretum and classify plants seen by their regions.

Projects and Lessons

Science

- **Discuss the four** essential items that a plant needs to live:

 - water
 - sunlight
 - air
 - soil

- Have students draw their own plant poster and label with the four necessary items. Display in a bulletin board area.

Math

- **How old are you, Mr. Tree?** After a lesson introducing the concept of "bark" as layers of outer "skin" on a tree, provide a variety of cut wood samples for students to count the "age" of a tree.

 - Classify tree samples from youngest to oldest—or for fun, into 4 categories:

 - baby
 - teenager
 - adult
 - senior citizen

Observation

- **Using the plotting grid** (p.51), provide each student (or teams of students) with a grid and a designated "plot" of land in the schoolyard. Using magnifying glasses, plot what is observed in the designated area including grasses, flowers, bugs, rocks, etc. Have students comment on their observations.

Science and Math

- **How many seeds?** Estimating/Predicting. Using large colored paper, sketch out a pumpkin, a strawberry, an apple and a tomato (or other available fruits/vegetables). Place onto a bulletin board or wall area. Provide crayons or markers for students to estimate how many seeds are in each fruit or vegetable. Provide the real fruit and have students divide into teams and count the seeds. Compare actual seed counts to the predictions.

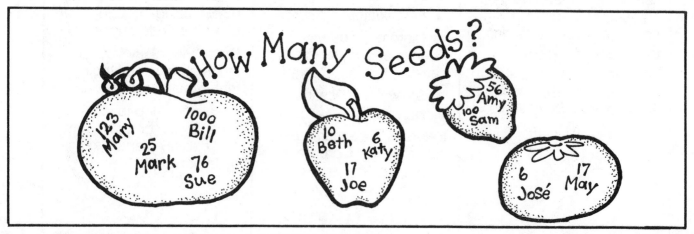

Name _____ Date _____

Sunflower "Sandwich" Sweets

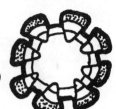

For each flower cookie treat:

1. Take _____ vanilla wafer cookies and place on a table. Spread a little frosting on the top of one cookie.

2. Place _____ pieces of candy corn on top of the frosting so it forms "petals."

3. Top with the other cookie. Use a little drop of frosting to "glue" _____ gumdrop on top of the cookie.

4. Poke a _____ inch piece of licorice rope into cookie center for stem.

5. For fun: Place _____ spearmint sugar leaf next to stem.

Number Words:

eight one three two one

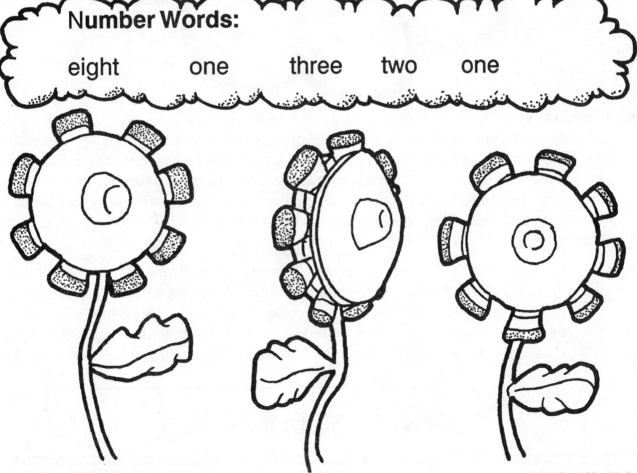

Math Facts Review

front

back

Directions: Make as many flower shapes as you will need. Glue to heavy tagboard for durability; color and cut out. In the circle write an operation sign (see operation signs below) and the number you want to review (see diagram). Punch holes along the perimeter of the flower. Write a different number next to each hole punched. Turn the flower over and write the answers to the problems next to the proper hole. Laminate and cut out. Staple two craft sticks together to the bottom of each flower placing one stick on each side of the flower.

To Play: One child faces the front of the flower, while another child faces the back of the flower. The child facing the front puts a pencil through a hole next to a number and says the problem aloud. (In the diagram, for example, each number will be multiplied by two. If the child puts the pencil in the four, he would say, "Two times four equals eight.") The child facing the back of the flower checks the answers. After all problems have been computed, the children trade places.

Operation Signs: +, −, X, ÷

26

Plant Scramble

Directions: Cut out the pictures and paste in the boxes in the order shown.

←— **Sunshine**

←— **Rain**

←— **Flower
and
Leaves**

←— **Stalk
and
Leaves**

←— **Roots
and
Soil**

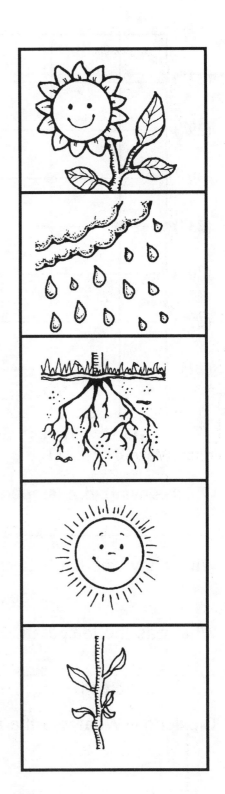

Line Graph

A line graph can give you information quickly. Study the graph below showing the daily temperatures in Mrs. Smith's classroom. Answer the questions below the graph.

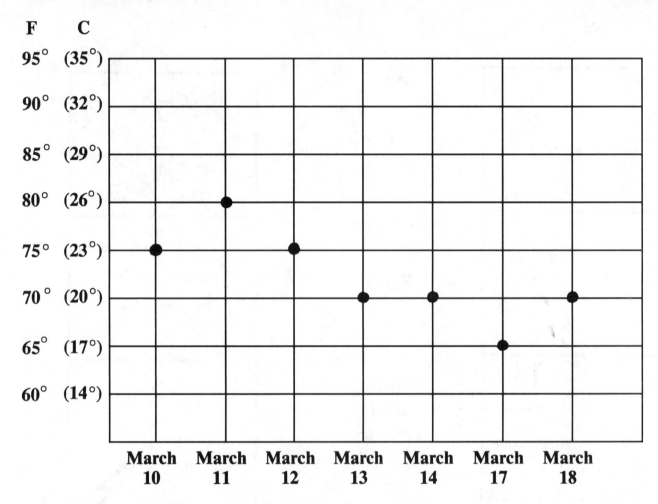

1. Which days had a temperature of 70°F (20°C)?

 _____ _____ _____

2. Which day was the hottest? _____

 coldest? _____

3. What was the temperature on:

 _____ _____ _____

 March 11 March 12 March 17

 Challenge: What was the average daily temperature?_____

28

Name _____ Date _____

March Open Worksheet

Directions: _____

- -

Answers: Cut and Paste

Name _____ **Date** _____

Hypothesis

A HYPOTHESIS is an idea you have about something you will be doing, seeing, or saying.

Example: "I think a plant will not grow in the dark because there is no light."

Complete this experiment by putting a plant in a closet for a week and observing. Was your hypothesis (idea) right?

Look at what these students said about a different experiment. Check the column after each statement to show if you think it is or is not a hypothesis.

Experiment Take 3 cups. Fill one with soil, one with rocks and one with clay. Plant a bean in each. Will the beans grow?	**Yes**	**No**
André "It will grow in the soil, but not in the clay or rocks."		
Susan "I like to plant the beans in the cups."		
Ling "The bean in the soil will grow the most."		
Bob "I want to give all 3 cups water today."		

Simple Experiments —Idea Bank

❀ Do plants need sunlight? Direct a plant with small leaves and flowers towards a window. After one week, turn the plant 180 degrees. Allow students to observe what happens over the following week.

❀ Can we "see" plants drinking water? Split the stem of a white carnation into 2 stalks. Place one side in a small glass containing blue water (food coloring) and the other in a glass containing red colored water. Allow plant to soak up water. In a few hours, the white flower will be brightly colored!

❀ Do all plants grow from seeds? Obtain an avocado seed (seed); ivy cutting (stem); sweet potato (root); and tulip (or other) bulb. Plant each accordingly and have students observe the growing patterns.

❀ What are plants used for? Make a chart divided into 4 sections and label FOOD, CLOTHING, SHELTER, THINGS WE USE. Have students find pictures (or draw their own) to cut and paste into each section.

❀ Can a plant grow in any kind of soil? Obtain different types of soil (rich, sandy, clay, rocky, etc.) Plant seeds and observe their growth. Plot growth on a line graph.

❀ Can we grow our own salad? Contact a local agricultural center for assistance in planning, plotting and planting an actual vegetable garden on your school grounds. Students will become the planters, caretakers, harvesters, and taste testers!

March People, Places, and Events

- ∘ **Alexander Graham Bell**
- ∘ **Johnny Appleseed**
- ∘ **Famous Women**
- ∘ **St. Patrick's Day**

Hot Tips!

☘ For St.Patrick's Day (March 17) have a "Golly Green" day. Ask all to wear green, plus bring in green treats for a green tasting party. Decorate room with green streamers and plants.

☘ Make your math lessons fun on St. Patrick's Day! First, count everything in the room that is green. Then, use those objects/numbers as a base for addition, subtraction, multiplication and division problems. For example: 4 books x 7 pencils = ?; 3 frogs - 2 paint brushes = ?

Alexander Graham Bell

(Birthday - March 3, 1847)

Mr. Bell was born in Edinburgh, Scotland in 1847. His father taught non-hearing people to speak correctly. Graham liked to work with his father, as well as to play musical instruments. He went to college to become a teacher of the deaf. Through his studies, he became interested in how words carry through the air. He worked for over nine years before he discovered how to do this through his invention—the telephone.

In his later years, he invented many other helpful ideas, such as phonograph records, echo sensors, electrical probes for surgery, and a lifting mechanism for airplanes. He died at the age of 75 in Nova Scotia.

1. **Knowledge**—What was Bell's first job? What were some of his inventions? What year did he die in?

2. **Comprehension**—Retell Mr. Bell's life story to a partner. Then, draw a picture of your favorite part of his life.

3. **Application**—Investigate how a telephone works. Make "model" phones with cups and string.

4. **Analysis**—Discuss how the invention of the telephone has changed history. What specific changes have happened because of this great invention?

5. **Synthesis**—Pretend that your class is on a "Telephone 2010 Team". Invent a telephone of the future. List its unique features.

6. **Evaluation**—Mr. Bell was very interested in enabling the deaf to become a more active part of society. Write a paragraph explaining why this is important for both hearing and non-hearing people alike.

Bookshelf Bargains

Today is 1/2 price day at the bookstore! Help the owner get the books ready by putting them in alphabetical order.

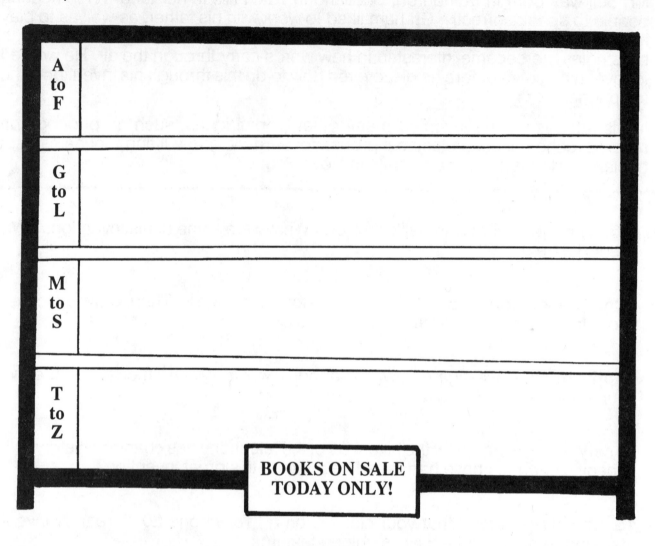

A to F

G to L

M to S

T to Z

BOOKS ON SALE TODAY ONLY!

✄ -

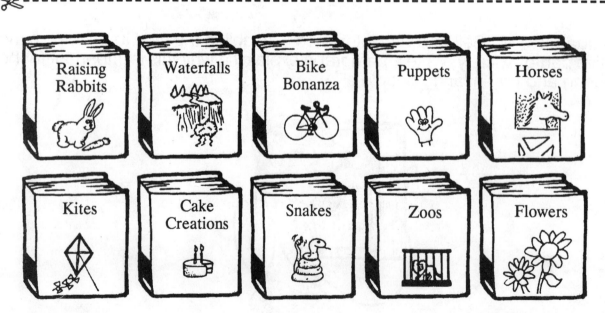

Raising Rabbits

Waterfalls

Bike Bonanza

Puppets

Horses

Kites

Cake Creations

Snakes

Zoos

Flowers

34

Famous Women Of The World

(International Women's Day - March 8)

Match the famous women to the countries in which they were born. (An encyclopedia can be very helpful!)

Marie Curie (Physicist)

Mother Teresa (Religious Leader)

Golda Meir (Prime Minister)

Eleanor Roosevelt (Humanitarian)

Margaret Thatcher (Prime Minister)

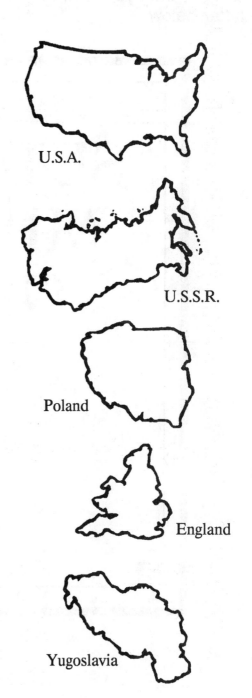

U.S.A.

U.S.S.R.

Poland

England

Yugoslavia

Bonus! Select one famous woman and list her lifetime accomplishments. Write her life story on the back of this paper. Share with your learning team or class.

The "Eyes" Have It!

(Save Your Vision Day — March 5)

Look at the eye chart. Find the hidden message by writing every second letter below.

SETYOEVTXH
MILNPKBYN
OAUCRKE
CGDRX
ESAL
T

" _ _ _ " _ _ _ _ _ _ _ _ _ _

_ _ _ , _ _ _ _ _ !

Name _____ **Date** _____

Albert Einstein's Science Riddles
(Albert Einstein's Birthday — March 14)

Riddle: What is as light as air but can't be held by Mr. Einstein for more than a minute?

Answer:

 —at + is —d + 3○ —irty

‎__ __ __ __ __ __ __ __ __ __ __ __

Riddle: How does Mrs. Einstein make Mr. Einstein's coat last?

Answer:

m + —c —i —e + st

‎__ __ __ __ __ __ __ __ __ __ __ __ __

Riddle: What smells best in Mr. Einstein's laboratory?

Answer:

—ll + s n + —h

‎__ __ __ __ __ __ __ __ __ __ __ __

Shamrock Measurements

(St. Patrick's Day - March 17)

Use a ruler and measure each shamrock's width. Record both inches and centimeters.

1.

_____ inches
_____ centimeters

2.

_____ inches
_____ centimeters

3.

_____ inches
_____ centimeters

4.

_____ inches
_____ centimeters

5.

_____ inches
_____ centimeters

6.

_____ inches
_____ centimeters

7.

_____ inches
_____ centimeters

38

Name _____ Date _____

Swallow Subtraction

(Swallow Day - March 19)

Match the wings to the correct answer. **GLUE ONLY** the tab of the wing, so you can lift up to see the answer!

Name _____ Date _____

Harry Houdini's Magic Boxes

(Birthday - March 24)

Mr. Houdini was famous for escaping from locked boxes. See if you can "escape" by solving these magic boxes! (The answers are the same across and down.)

1. __ __ __ ing pan
2. __ __ __ Grande
3. Me and __ __ __

1. Cleans a floor
2. 7 - 6 = __ __ __
3. Used for writing

1. Worn on your head
2. Already eaten
3. Iced __ __ __

1. Full-grown kitten
2. __ __ __ Lincoln
3. 9 + 1 = __ __ __

1. Opposite of lose
2. __ __ __ cream
3. Opposite of old

1. Frying __ __ __
2. A long time __ __ __
3. Why __ __ __ ?

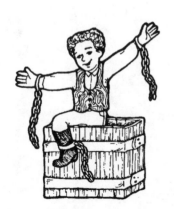

1. Another name for father
2. __ __ __ you going, too?
3. A lion's __ __ __

Name _____ Date _____

Memory Mix-ups

(Memory Day - March 21)

Directions:

1. Reproduce this page for each student.

2. Have students work in pairs.

3. Have students cut out their own squares.

4. The first person arranges the squares in their frame.

5. The partner studies that frame for 10 seconds; looks away; puts the same pattern of pictures on his or her frame.

6. Take turns!

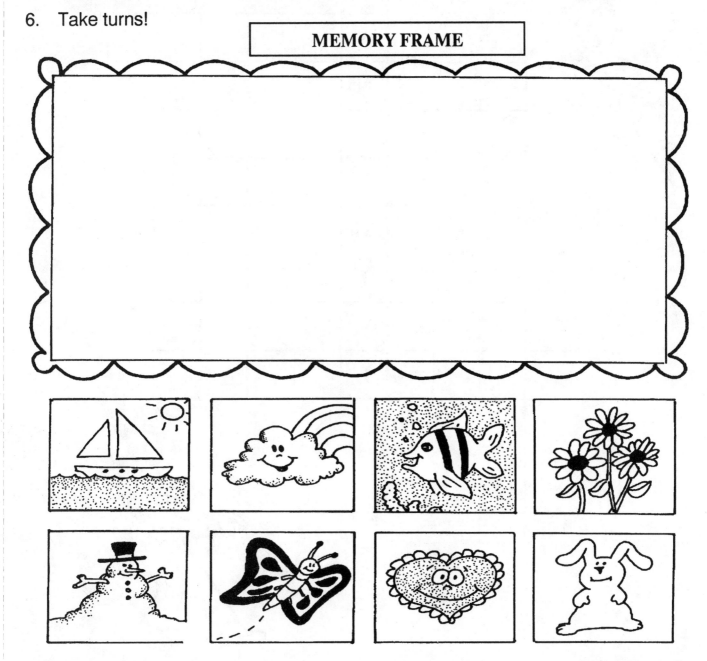

MEMORY FRAME

Name _____ Date _____

Marcel Marceau Crossword

(Birthday - March 22)

Directions: Use the **bold** words from the paragraph below to fill in the "no word clues" crossword puzzles. (One has been done for you.)

Marcel **Marceau** was **born** in **France**. He is called a "Pantomimist." This means he acts without saying any words. He tells stories with his **hands** and face. **Pantomime actors** usually make their face look **white** with special face **powder**.

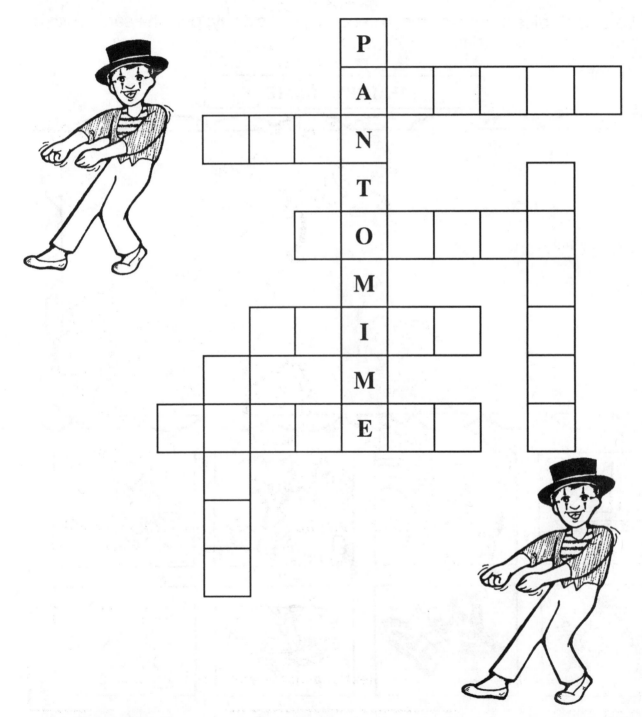

Name _____ Date _____

Colors of Spring

(First Day of Spring - March 20)

Use the color combination key to color your picture.

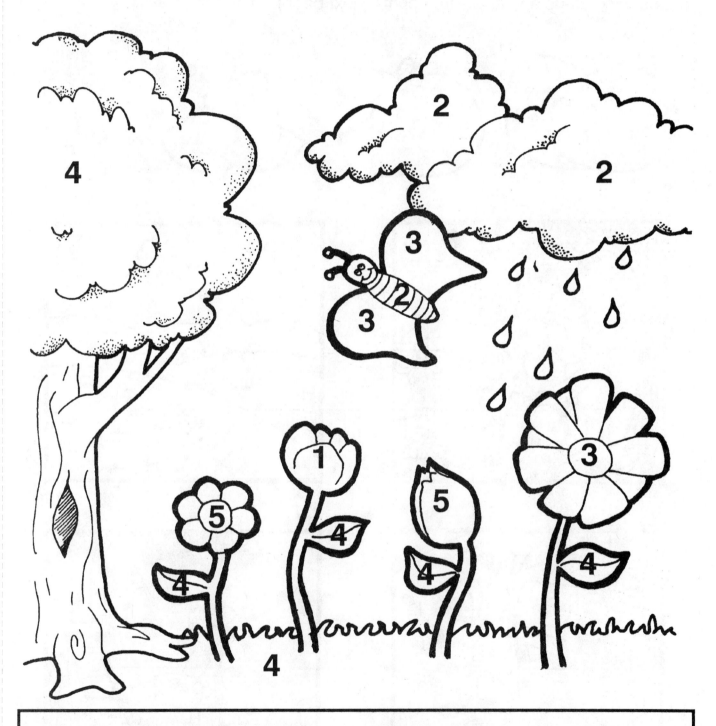

white + red — 1	yellow + blue —4
white + black — 2	blue + red —5
red + yellow — 3	Rest of picture—any colors

43

Johnny Appleseed Day

(March 11)

To introduce students to Johnny Appleseed, provide each child with the 4 sequencing pictures and a strip of paper. As you read the story on page 45 have them glue down apples and pictures in the correct sequence. Decorate a bulletin board area with sequencing strips and apple tree prints (next page).

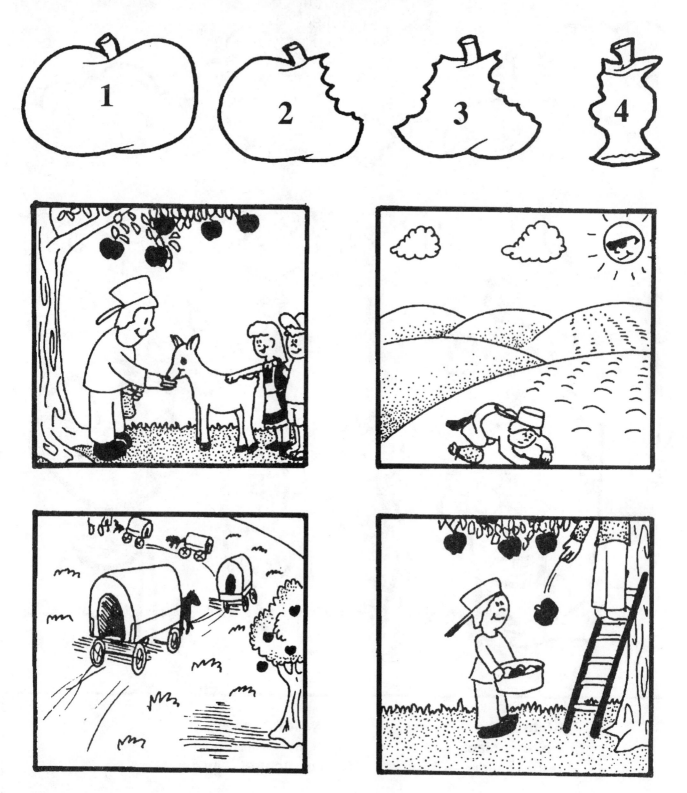

Johnny Appleseed

Johnny Chapman was born in 1774 in Massachusetts. He lived on a farm where he helped his father with many chores. His favorite was working in their apple orchard. As he was growing up he could see wagon trains going past to discover the land out west. Some of the drivers told Johnny the land was perfect for growing crops, and that there were no apple trees in the west. He decided to change that! He left his father's farm with large sacks full of apple seeds. He planted lots and lots of apple seeds on his long journey. Everywhere that Johnny went, apple trees were sure to grow—and they did!

As Johnny grew older, he settled down and started his own apple tree farm. Animals loved to come to his farm for the pieces of bread Johnny would leave for them. Children used to visit also and hear about all of the wonderful places Johnny had gone to plant his apple tree seeds.

Apple Tree Prints

Materials:

apples (cut in half)

green and red tempera paint

brown construction paper

glue

background paper

crayons or markers

Directions:

1. Rip brown paper to form trunk. Glue onto background.

2. Press cut half of apple into thinned green paint, press repeatedly onto picture above trunk to form leaves.

3. Have students use own thumb and press into red paint. Then, press onto green area to make apples. Allow to dry.

4. Use crayons or markers to add finishing touches!

A Doctor's Day

The doctor is having a busy day! Look at the clock next to each picture. Then, write the time.

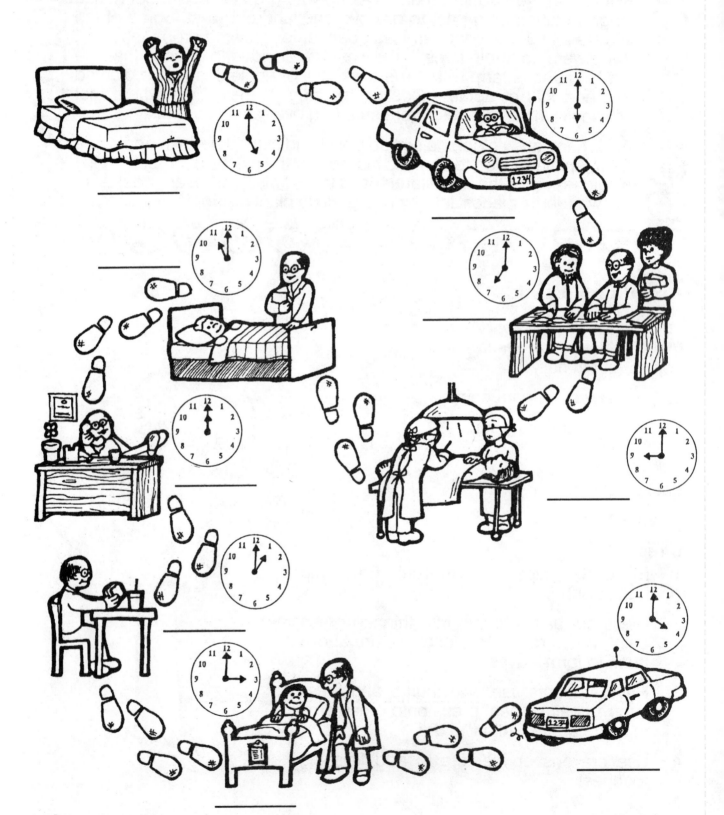

46

March Management

- ◦ **Clip Art**
- ◦ **Contracts and Awards**
- ◦ **Holiday Report Form**
- ◦ **A Month of Writing**
- ◦ **And More!**

Hot Tips!

🍀 Make your own notepads by stacking paper carefully and applying a layer of rubber cement to one edge of the papers. Let dry — and — instant notepad!

🍀 Sometimes, improving behavior can be managed by using a contract, just like educational assignments. Use the behavioral contract (p.55) to give a student responsibility for changing their own behavioral patterns.

Name _____ Date _____

A Month of Writing

 March is the third month of the year. For a daily writing activity, give your students a choice (out of three, to be exact!) of topics to write about each day. Allow students to share their stories orally with the class or in teams. Place all writings into a "March Memories" booklet.

1. Bug, Bat, Bumblebee	16. January, June, July
2. House, Helicopters, Horse	17. Singing, Saying, Signing
3. Toe,Teeth, Tailbone	18. Brown,Blue, Black
4. Spaghetti,Salad, Soup	19. Candy, Cake, Cookie
5. Picture, Platter, Pitcher	20. Telephone, Television, Tape Recorder
6. Computer, Calculator, Calendar	21. Movie, Musical, Memory
7. Green, Gold, Grey	22. Stars, Spaceship, Satellite
8. Farm, Factory, Fishery	23. Africa, Australia, America
9. Door, Desk, Drawer	24. Mouse, Muskrat, Moose
10. Pencil, Pen, Paper	25. Parade, Picnic, Play
11. Mystery, Magic, Music	26. Vine, Vase, Violet
12. Sheep, Shark, Snake	27. Wallet, Watch, Wetsuit
13. Police, Plumber, Painter	28. Happy, Hilarious, Homebody
14. Break, Build,Bend	29. Swim, Sail, Ski
15. Car, Carriage, Cart	30. Baseball, Bowling, Boxing

Spring-time

Living

Living/Non-Living Books

Supplies needed (per book)

1 8 1/2" x 11" sheet of colored paper

4-6 plastic self-sealing sandwich bags

scissors

stapler

marking pen

Directions:

1. Fold colored paper in half.

2. Layer sandwich bags on top of each other and place inside of folded paper along crease.

 Important Note: Be sure that the bag openings are facing **away** from the crease edge.

3. Staple along crease side of folded paper, catching all of the bags.

4. Write "My Living/Non-Living Book" on cover.

5. Allow students to go outside and place living and non-living things into the separate baggie "pages."

50

My Plotting Grid

Record all you see in your observation area. Make your comments in bottom section.

Name: _____

Comments: _____

March Record Form

Name										

Name _____ Date _____

Homework!

Use these flowers to keep track of your assignments. Color the petal when assignment has been completed.

Mon

Tues.

Wed.

Thurs.

Fri.

Invitation/Thank you

Luck o' The Irish!

You've been invited to:

Thank You.

54

Contract/Award

My Behavior Contract

I will try my best to not be a lion, but instead a lamb.

I will: _____

For my new behavior, I will receive:

My name: _____

Teacher: _____

Date: _____

A FANCY FOOTWORK AWARD

for: _____
(Student's name)

You have done a fancy toe-tappin' job at figuring out how to solve a pressing problem...

Problem: _____

Your solution: _____

_____ _____
Teacher Date

Plant Partner Poster

(Draw your own face; color.)

I PROMISE TO DO MY BEST TO BE A PLANT PAL!

Yeah! It's Field Trip Time

We are going over the rainbow to see...

on_____ at _____.

We will be returning at _____.

We are going because _____

_____.

Please provide:_____

**If you can help in any way, please
fill out comment section below.**

Thank you!

✂ -

Please ✓

☐ Yes, my child has permission to go.

☐ No, my child may not attend.

Student's Name: _____

Parent Signature: _____

Phone: _____

Comments: _____

Award

My name is: _____

My favorite event this week was: _____

because _____

Here is a drawing of me when I: _____

Week of: _____

I learned about: _____

I felt proud when: _____

I helped _____

when I _____

I improved in: _____

I'm proud of my success at school. Take time and look to see what I have felt good about this past week.

March Bookmarks

Completed
Project

Materials
- *bookmark pattern*
- *tagboard*
- *crayons or colored markers*
- *scissors*

Directions

Note: *Make a pattern out of tagboard. Have a child use the pattern to make his own bookmark.*

1. Trace around pattern onto tagboard.

2. Draw an object, animal, or other shape in the square at the top of the bookmark pattern. (Supply lion/lamb, flower, or leprechaun patterns below, if desired.)

3. Cut out.

4. Color the design with crayons or marking pens.

Bookmark
Pattern

Have students collect stickers and awards on their bookmarks.

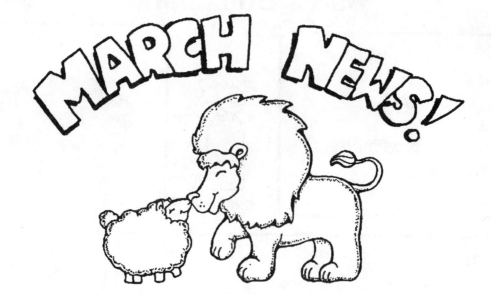

MARCH NEWS!

May I Be Excused?

Here are some ideas to help you minimize daily "May I be excused?" interruptions. Choose the one that best fits your needs.

■ **Stoplight** — This allows one student to leave the room at a time. Make a traditional stoplight out of construction paper. Mount to tagboard that has been divided into two sections:

red ►

yellow ►

green ►

Bobby G.

clothespin

I CAN GO	I CAN NOT GO

I CAN GO • (green) I CAN'T GO (red)

Write your students' names on *both* sides of a clothespin. Clip each clothespin next to a green dot. Then, when you are busy working with small groups, or at other pre-determined times, a student may go up to the light and remove their name from the green dot, clipping it to the yellow light of the stoplight (warning others that someone is in the restroom or out of the room). Then, when the student returns, he removes the clothespin from the yellow light and places it next to the red dot. At the end of the day, place all clothespins back on the green dot side.

■ **Apple Time** — Decorate a bulletin board with a tree that has a "hole" in the trunk. Randomly place pins in the "leaf" area. Write each student's name on an apple and place in a paper basket next to the tree. Students put their apple in the hole when leaving the room or using the restroom, then hang it on the tree when they're done. Remove and place back into basket at the end of the day.

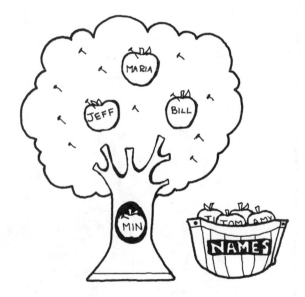

■ If students are older:

— allow only at recess, lunchtime, or before/after school.

— Go by tables/teams.

Adopt-A-Class

Here's a great way to build reading skills through the use of literature. (Plus it's easily extended into a cooperative learning experience.)

Process:

1. Pair two classes together (at least two grade levels apart)

 Example:
 Mr. Fish's First Grade with Mrs. Olson's Fourth Grade

2. Have older students become teacher/tutors to younger students. The teacher first gives instructions and advice to older students, then pairs up "teams" of one older and one younger student.

3. On "Love To Read" day, allow teams to meet in cozy spots around the room. (It works well if half of the older students go to the younger room, while the other half remains and waits for half of the younger students to come to them.)

4. For approximately one half hour, have older students read an appropriate level book to younger student. The younger students then retell story or answer questions posed by the older students. To complete the exercises, have the younger students dictate the story back, while the older student records it onto writing paper. Then they illustrate favorite part of story together. The "team" then keeps their journal.

62

March Clip Art

Stationery

Big Patterns

Big Patterns

66

Big Patterns

Dear Parents,

Ewe's special to me! Could you please help our special activities/events this month by sending any of the following items:

Thank "ewe" so much,

(Teacher)

March
Bulletin Board

- ○ **Complete Directions**
- ○ **Patterns**
- ○ **Suggested Uses**

Plant-astic plant facts

Hot Tips!

To store bulletin board patterns—use large plastic sacks, punch small hole near top edge and thread over curved portion of metal hanger and hang bags in a closet area.

Take a snapshot of completed bulletin boards. Keep in a file box for easy reference in the coming years!

March Bulletin Board

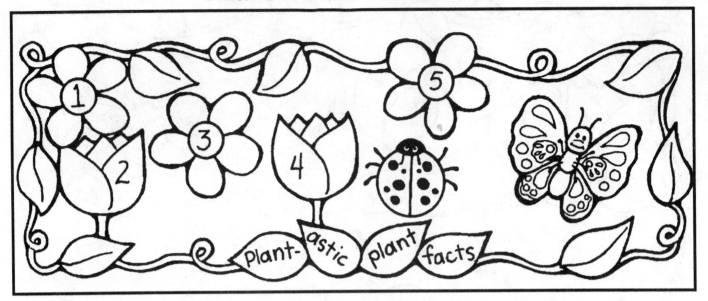

OBJECTIVES

This bulletin board can be used as shown for an interactive part of your thematic unit, or it can easily be adapted to introduce/reinforce math, reading, or language skills.

MATERIALS

colored construction paper green ribbon

light green paper or material (for background)

marker scissors stapler pipe cleaners

CONSTRUCTION

- Reproduce patterns onto appropriately colored construction paper and cut out.
- Assemble pieces onto background:

1. Twirl green ribbon loosely as you staple to give "vine" effect.
2. Staple leaves onto vines (staple one end—"poof out"—then the other end for a 3-D effect). Remember to write the title of bulletin board onto four of the leaves before stapling!
3. Staple flowers onto background.

DIRECTIONS/ EXTENSIONS

- Write plant facts on cards. As class reviews them, post next to numbered flowers.
- Write questions on center of flowers. Place answers on back of petals.
- Use flowers as sequencing numbers for sequence stories or events.

Patterns for Flower

Make as many as needed.

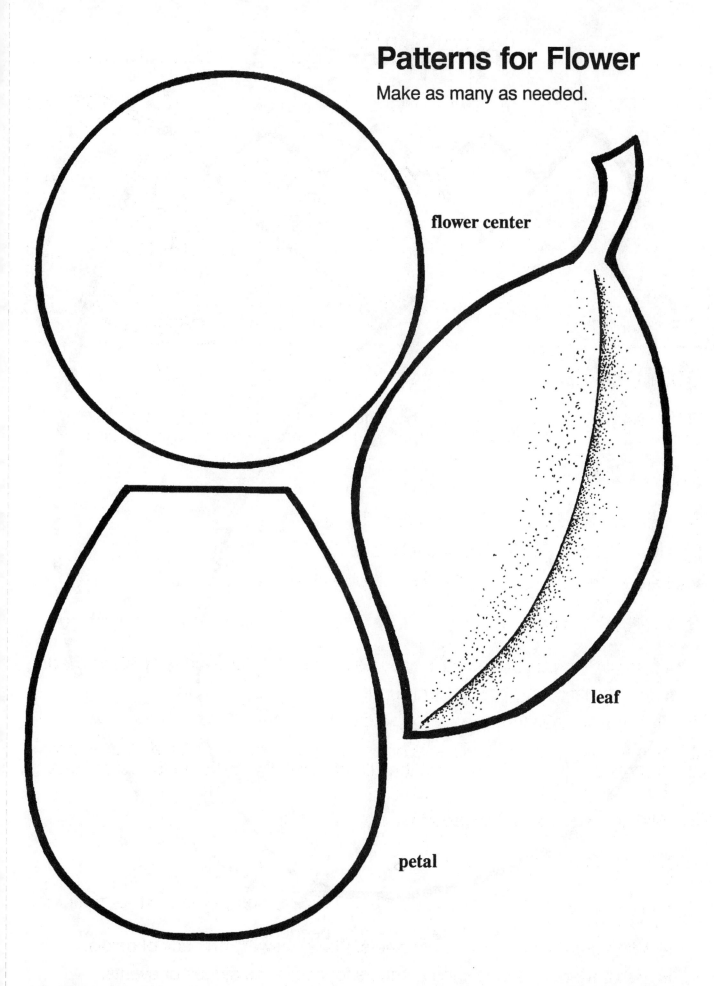

flower center

leaf

petal

Pattern for Tulips

Make as many as needed.

Butterfly

Attach on top of Tab A (page 74).

Butterfly

Tab A

74

Ladybug

Attach pipe cleaners to X's to make legs and antennae.

Attach to center of butterfly wings.

#157 March Monthly Activities

Answer Key

p. 8-9 Calendar of Events

1. One who works without monetary payment.
2. Theodore Geisel
3. Telephone
4. January, March, May, July, August, October, December
5. You can read the bottom line of an eye chart at 20 feet.
6. San Antonio, Texas
7. He studies plants.
8. Answers will vary.
9. Lamb
10 A group of people who secretly smuggled slaves to free states or to Canada.
11. Keep the doctor away.
12. Answers will vary.
13. Yes, one.
14. Energy equals mass times the speed of light squared.
15. Answers will vary.
16. A few are: oranges, potatoes, tomatoes, strawberries, cabbage
17. A famous stone in Ireland that is kissed for good luck.
18. Russia
19. Over 200 years.
20. Summer, fall, winter
21. Answers will vary.
22. Acting without words or noises.
23. Patrick Henry
24. Magician.
25. George Washington, Thomas Jefferson, Theodore Roosevelt, Abraham Lincoln
26. Answers will vary.
27. Twelve
28. A scrub board and bucket.
29. Answers will vary.
30. Answers will vary.
31. Tenth

p.15 Green Things

p. 25 Sunflower Sweets

1. two
2. eight
3. one
4. three
5. one

p.28 Line Graph

1. March 13, 14, 18
2. **Hottest**–March 11

 Coldest–March 17
3. **March 11**–80° F (26° C)

 March 12–75° F (23 °C)

 March 17–65° F (21° C)

 Challenge–72° F (21° C)

p.30 Hypothesis

Andre-yes Susan–no
Ling-yes Bob–no

p.34 Bookshelf Bargains

A to F-Bike Bonanza, Cake Creations, Flowers
G to L-Horses, Kites
M to S-Puppets, Raising Rabbits, Snakes
T to Z-Waterfalls, Zoos

p.35 Famous Women of the World

Madame Curie-Poland
Mother Teresa-Yugoslavia
Golda Meir-U.S.S.R.
Eleanor Roosevelt-U.S.A.
Margaret Thatcher-England

p.36 The "Eyes" Have It!

"Eye" think you're great!

p.37 Albert Einstein's Science Riddles

His Breath
Makes Pants First
His Nose

p.38 Shamrock Measurement

1. 2 in.; 5 cm.
2. 1 in.; 2.5 cm.
3. 3 in.; 7.5 cm.
4. 2 1/2 in.; 6 cm.
5. 3 3/4 in.; 9.5 cm.
6. 1/2 in.; 1 cm.
7. 1 in.; 2.5 cm.

Answer Key

(cont.)

p.39 Swallow Subtraction

Row 1 —	33	57	87
	−10	−22	−36

Row 2 —	12	26	18
	− 7	−13	− 7

Row 3 —	99	93	78
	−32	−60	−28

p.40 Harry Houdini's Magic Boxes

p.42 Marcel Marceau Crossword

```
                P
                A  C  T  O  R  S
       B  O  R  N
                T              F
             P  O  W  D  E  R
                M              A
          W  H  I  T  E        N
       H        M              C
    M  A  R  C  E  A  U        E
       N
       D
       S
```

p.43 Colors of Spring

white + red = pink
white + black = grey
red + yellow = orange
yellow + blue = green
blue + red = purple

p.46 A Doctor's Day

5:00,6:00,7:00,9:00,11:00,12:00,1:00,3:00,4:00

Open Worksheets Skills

These pages are ready to use. Simply fill in the directions and write the skill you want to reinforce. Make a copy for each student or pair of students or glue the worksheet to tagboard and laminate. Place at an appropriate classroom center; students can use water-based pens for easy wipe off and subsequent use. Ideas and resources for programming these worksheets are provided below and on the following pages.

Math

Basic facts
Comparing numbers and fractions
Decimals
Word problems
Time
Place value
Skip counting
Ordinal numbers (1st, 2nd, 3rd, etc.)

Sets
Missing addends
Money problems
Geometric shapes
Measurement
Word names for numbers
Sequence
Percent

Roman Numerals

I - 1
II - 2
III - 3
IV - 4
V - 5

VI - 6
VII - 7
VIII - 8
IX - 9
X - 10

L - 50
C - 100
D - 500
M - 1,000
L - 50,000

Metric Measurement

mm - millimeter (1/10 cm)
cm - centimeter (100 mm)
dm - decimeter (100 cm)
m - meter (1,000 mm)
km - kilometer (1,000 m)

g - gram
kg - kilogram (1,000 g)
l - liter (1,000 ml)
ml - milliliter
cc - cubic centimeter

Measurement Equivalents

12 in. = 1 ft.
3 ft. = 1 yd.
5,280 ft. = 1 mi.

4 qt. = 1 gal.
2 pt. = 1 qt.
8 oz. = 1 c.

1 t. = 2,000 lbs.
60 sec. = 1 min.
60 min. = 1 hr.

Open Worksheet Skills

(cont.)

Abbreviations

Names of states	dr. - drive	mt. - mountain
Days of the week	ave. - avenue	p. - page
Units of measurement	Dr. - Doctor	etc. - et cetera
Months of the year	Mrs. - Misses	yr. - year
blvd. - boulevard	Mr. - Mister	wk. - week
rd. - road	Gov. - Governor	
st. - street	Pres. - President	

Contractions

isn't - is not	I've - I have	they'd - they would
doesn't - does not	we've - we have	you'll - you will
haven't - have not	I'm - I am	won't - will not
hasn't - has not	you're - you are	I'm - I am
that's - that is	it's - it is	let's - let us

Compound Words

airplane	bodyguard	everywhere	percent
anyhow	bookcase	footnote	quarterback
anything	cardboard	grandfather	snowflake
basketball	classroom	handwriting	suitcase
bedroom	earthquake	makeup	watermelon

Prefixes

dis -	un -	over -	re -
disapprove	uncut	overcharge	recover
discolor	uneven	overdressed	redo
discount	unfair	overdue	reheat
dislike	unhappy	overfeed	remiss
dismay	unlike	overgrown	replay
dismiss	unmade	overpaid	reset
disobey	unwashed	overrun	review

Suffixes

- ful	- less	- ly	- en
beautiful	ageless	actively	harden
careful	homeless	happily	moisten
helpful	priceless	quickly	sweeten
skillful	worthless	silently	thicken

Open Worksheet Skills

(cont.)

Plurals

- s

toe	kitten
pin	window
lamp	star
book	key

- es

church	class
lunch	inch
box	tomato
brush	waltz

- ies

sky	cherry
baby	body
party	army
family	lady

Anagrams

dear - dare - read
notes - stone - tones
fowl - flow - wolf
veil - vile - evil - live
tea - ate - eat

shoe - hoes - hose
vase - save
pea - ape
north - thorn
flea - leaf

veto - vote
cone - once
stop - tops - pots - post - spot
steam - meats - mates - tames

Synonyms

sleepy - tired
firm - solid
story - tale
shut - close
easy - simple

wealthy - rich
quick - fast
sea - ocean
icy - cold
chore - task

friend - pal
tiny - small
jump - leap
gift - present
hike - walk

Antonyms

empty - full
tame - wild
city - country
faster - slower
strong - weak

tall - short
rough - smooth
light - dark
dirty - clean
calm - nervous

correct - wrong
forget - remember
thick - slender
sweet - sour
young - aged

Homonyms

eight - ate
whole - hole
red - read
hour - our
peace - piece
lone - loan

pale - pail
knew - new
nose - knows
blew - blue
would - wood
for - four - fore

by - buy - bye
sense - cents - scents
two - too - to